**EGO
The Difference Between
Telling and Selling**

Gingko Press

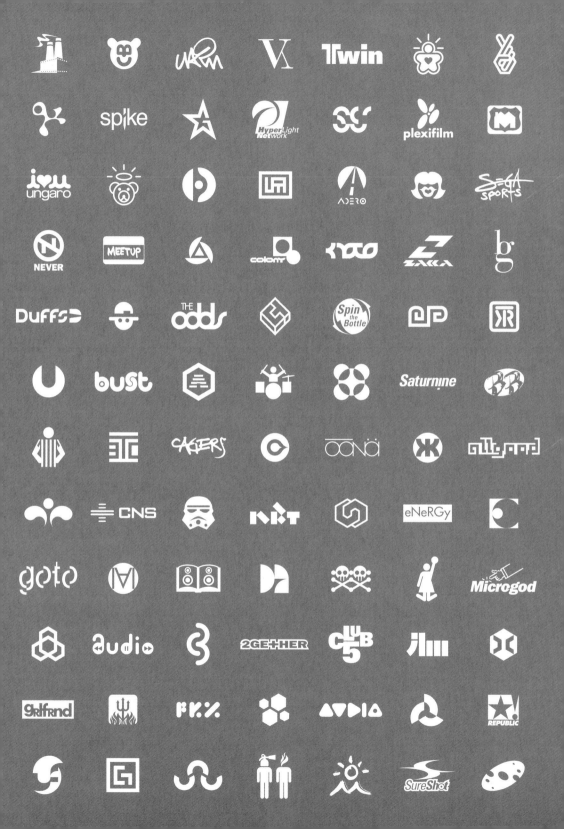

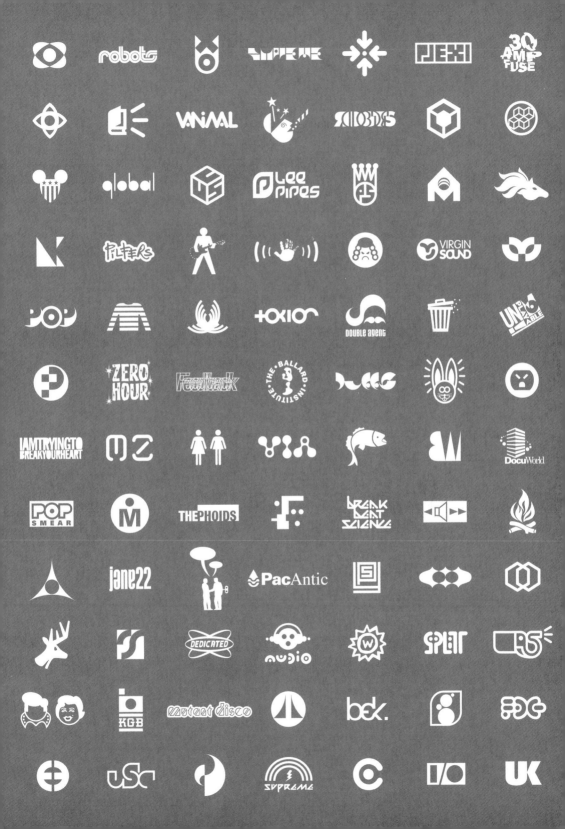

EGO
THE DIFFERENCE BETWEEN
TELLING AND SELLING

Published by
GINGKO PRESS INCORPORATED
5768 Paradise Drive, Suite J
Corte Madera, CA 94925
www.gingkopress.com

© 2003 EGOSUM INCORPORATED

ISBN 1-58423-146-7

First published in USA in 2003
Printed and bound in Germany

EGO

EGOSUM INCORPORATED
215 Centre Street
New York, NY 10013
egosum.com

Contents

Introduction

A company's or product's visual identity is arguably its most important attribute. Whether or not the identity accurately conveys the characteristics of that company or product, the physiognomy of an entity as described by graphic elements largely determines its perception by the public. The pedigree of a company with strong values and a long history can be undermined by a weak visual identity, just as a fly-by-night operation can give the impression of years of experience in a particular industry with a strong, well-executed logo.

A visual identity can therefore serve dual purposes: it can accurately reflect the nature of the entity it represents or it can deliberately mask that nature. For example, a logo can be used strategically to make a huge, multinational corporation look "indie" or to make a small upstart company look well established, depending on the goals of the company in question: telling or selling.

Although the goals of a company often involve both, there is a difference between telling and selling. Between illumination and illusion. Between design and advertising.

Advertising has no higher objective than making consumers want to buy a product or service. Advertising is the employment of design for the sole purpose of selling.

At its best, design has the ability to propel a society forward by improving way-finding systems, clarifying convoluted information hierarchies, and enhancing the outward appearance of a community, from billboards and shop signs to magazine advertisements and book jackets. Design can bring together disparate cultures by providing a common language based on a symbology that transcends mere letterforms. Good design can be a fierce opponent to the stentorian march of entropy.

However, not all design is good. If good design is defined as thoughtful ideas well executed, there are two potential barriers to achieving it: lack of a thoughtful idea and poor execution.

Because of the fundamental purpose of design—to communicate—the lack of a unifying idea is tantamount to failure in designing an identity. As such, the first step in developing an identity is to extract the message to be communicated.

At its worst, design may run the risk of creating a monoculture, as in the case of Swiss modernism. Ironically, this occurs when a unique solution is so timely and communicates so well that an army of enthusiastic, if mimetic, designers is ready to execute the solution for any message that comes along, whether or not the medium fits the message. The risk of this is greatest when design is used to sell rather than to tell.

Any given business has two main objectives: building its own brand awareness and selling goods or services. While neither objective is inherently more important than the other, the execution of each requires a different approach. Therein lies the dichotomy of graphics for hire: telling versus selling.

Telling involves thoughtful communication of a company's principles without the added burden of moving units per se. However, when selling is the objective, substantive communication is often forsaken for showy, style-based work that can be executed quickly.

EGO is a design firm interested in telling.

Good design isn't created; it reveals itself. EGO's role is to facilitate that process by simplifying forms to communicate only the essential.

Assembled in this book is a collection of EGO's work that demonstrates this philosophy of straight-forward solutions derived from efficient use of form and color.

While mindful of the pragmatic concerns inherent in creating corporate identities and icons, EGO injects a playful, witty element into its design solutions, which appeals to its broad clientele.

EGO's process begins with a thorough understanding of its clients' business philosophy, and continues by distilling and articulating those beliefs using the most direct visual language possible. This exhaustive search for form integrity is aimed at universal communication that aids clients in fulfilling their desire to tell.

EGO's process-driven approach to designing logos and icons for clients is exhibited in twelve case studies included at the end of this portfolio. Each project's journey is documented through sketches, outtakes, and alternate endings, emphasizing the non-linear, often organic, development of thoughtful design.

Case Studies

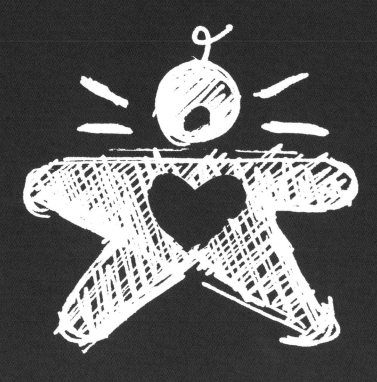

Baby Press Conference

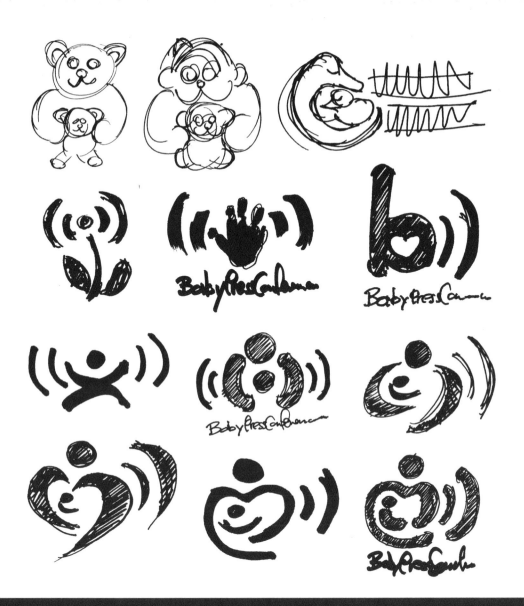

Objective: Design a logo for a hospital's on-line broadcast service that lets users introduce newborns to friends and family through a free live-action video netcast.

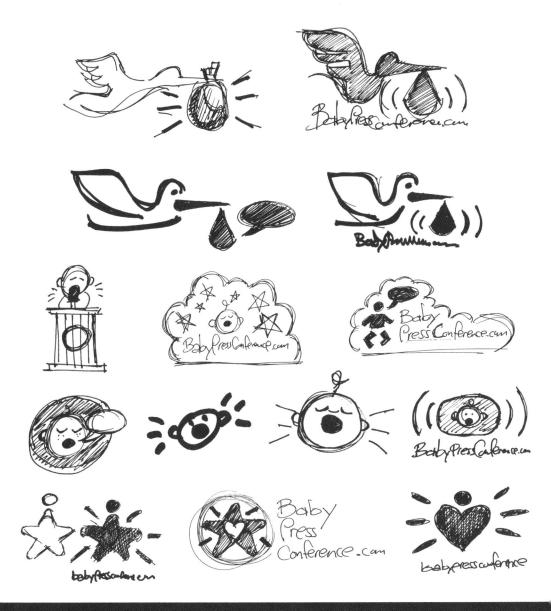

Process: After initially developing a range of symbols representing the baby and parent, EGO replaced the parent with a stork.

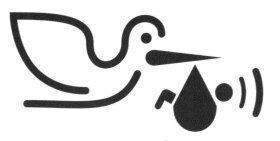

BabyPressConference.com™

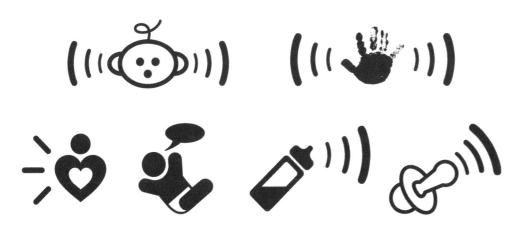

However, the stork placed too much emphasis on the delivery of the baby. Symbols for the baby with radiating broadcast lines shifted the focus to the two essential issues: baby and broadcast.

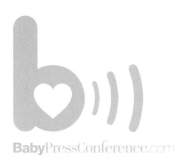

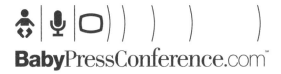

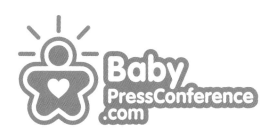

A lowercase "b" alludes to a pregnant form but implies a pre-birth broadcast. The symbol narrative works well with the long company name, but becomes too linear and clumsy for applications.

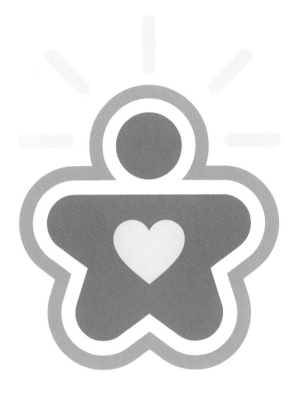

Solution: A radiating/broadcasting baby star symbol in soft, unisex colors.

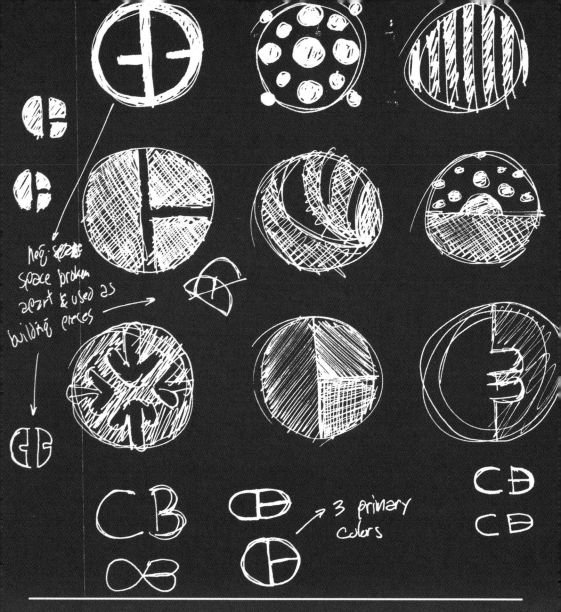

neg. space broken apart & used as building pieces

3 primary colors

Consolidated Baily

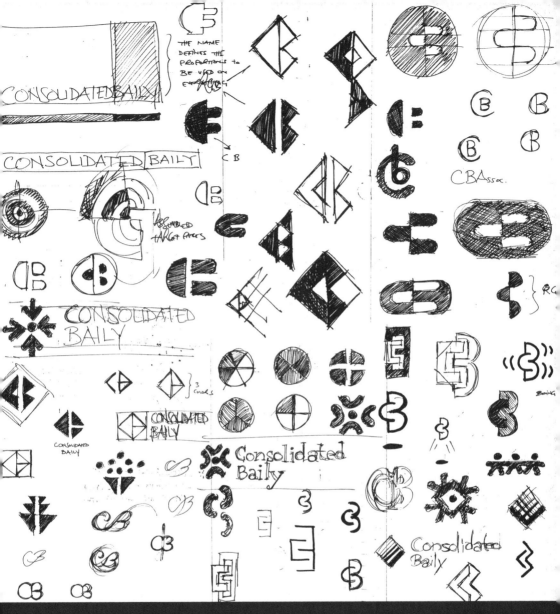

Objective: Develop a corporate identity system for a global entertainment branding firm to convey the levity of their company personality while maintaining a professional image.

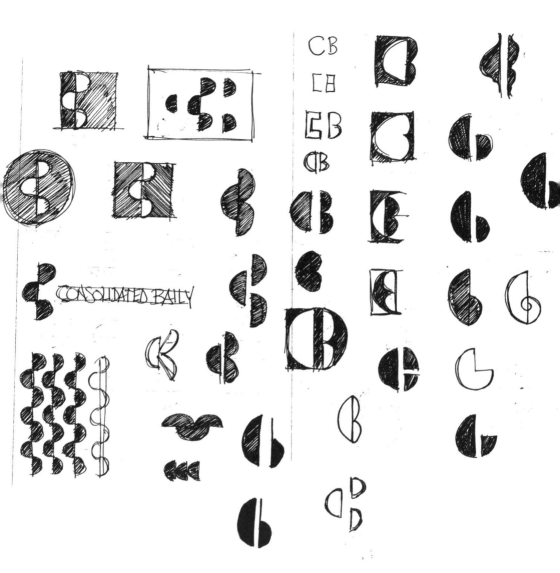

Process: EGO looked at various forms derived from the company's initials. The search concentrated on forms that were solid and bold as well as playful.

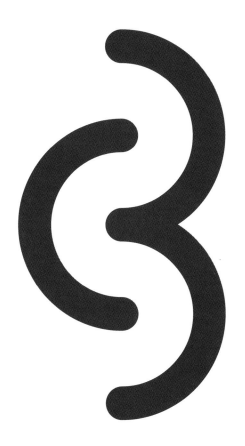

This solution signals fun motion with its springy and spongy lines, while connoting Consolidated Baily's problem-solving approach with its maze-like negative space. However, the mark ultimately proved to be too abstract and generic.

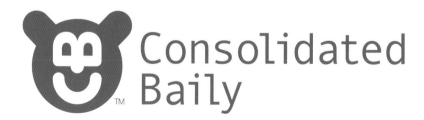

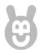 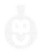 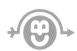 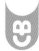

Solution: A unique identity system that positioned the "C" and "B" to form a cartoon face, which serve as the basis for the new company logo.

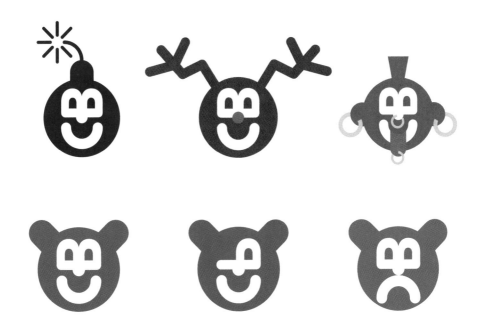

**The dynamic logo character is expressed
in numerous variations so that the collection
as a whole builds the company's multi-
faceted identity.**

Double Agent

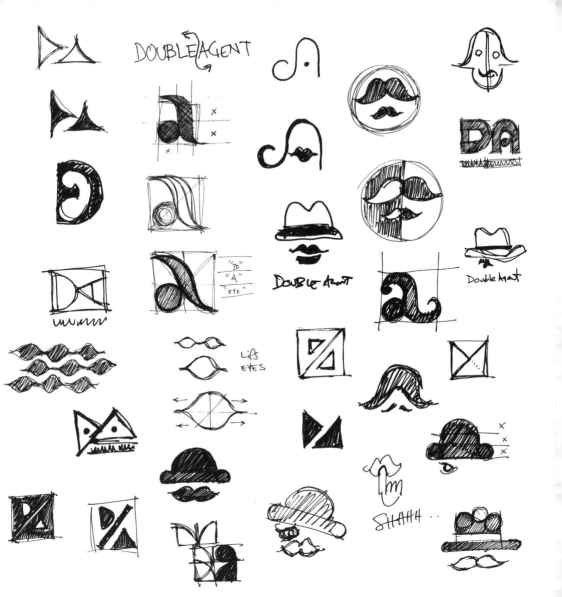

Objective: Design an identity system for a daily email magazine for men, by women.

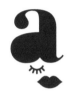 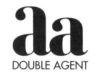 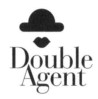 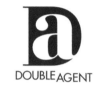

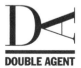

 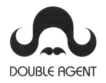 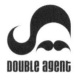 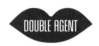

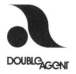 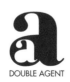 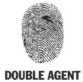 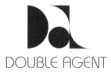

Process: EGO explored a range of interpretations of the company name with dual-purpose letterforms, women in disguise, fingerprints, and back-stabbing capitals.

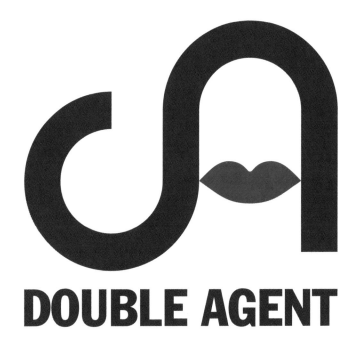

DOUBLE AGENT

This ligature of the company's initials creates the head of a woman with a stylized hair flip. The red lips punctuate the mark and serve as the crossbar for the "A".

Solution: A system more versatile and appropriate for the target audience that can be updated daily with the silhouette of a different "Double Agent."

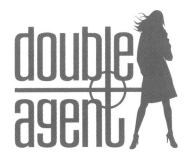
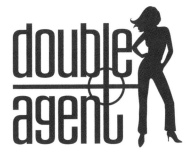

 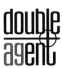 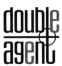

By repeating letterforms within the typograph-
ic mark, EGO created a logo that makes subtle
references to the company name.

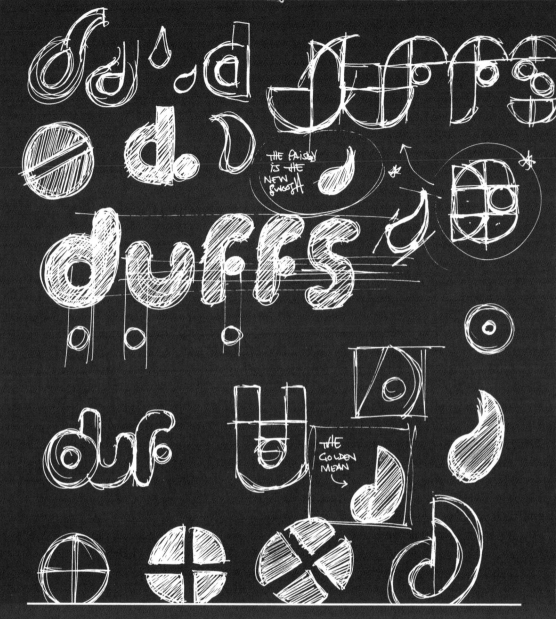

THE PAISLEY IS THE NEW SWOOSH

THE GOLDEN MEAN

Duffs

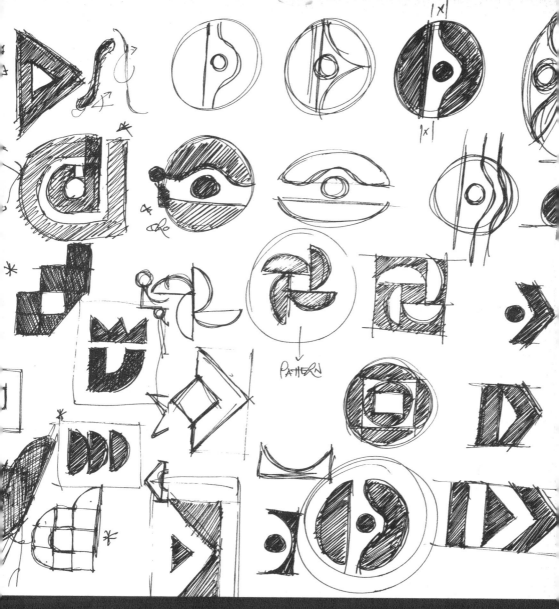

Objective: Re-brand a leading international manufacturer of skateboarding shoes and apparel.

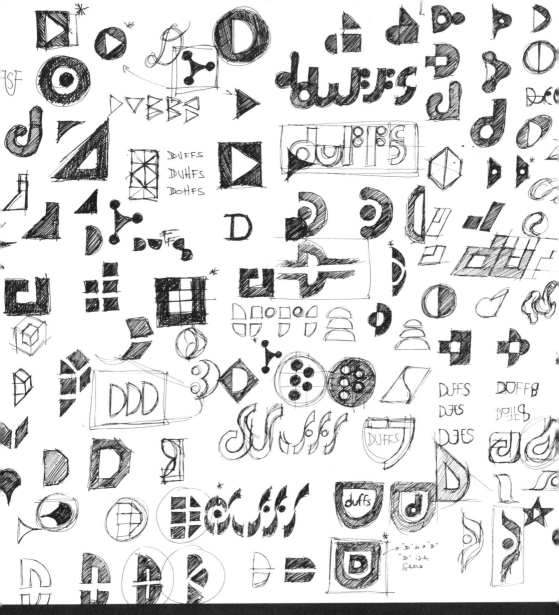

Process: An abstracted "D" served as the point of departure in the search for a form that communicated forward motion.

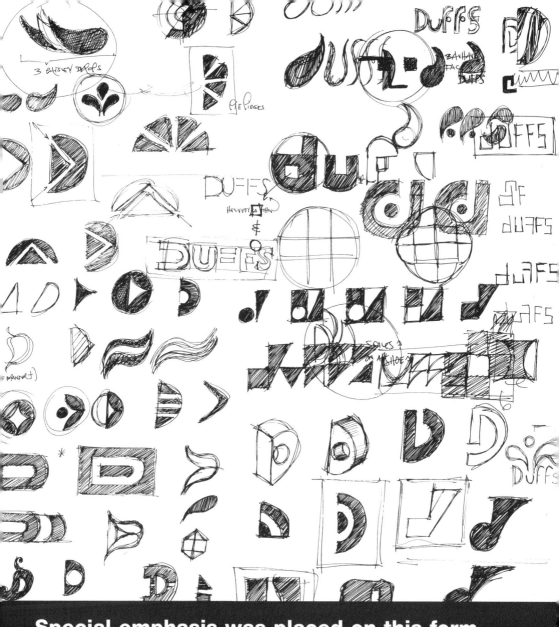

Special emphasis was placed on this form, as it would have to stand alone without the reinforcement of the "Duffs" name.

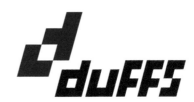

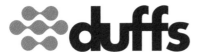

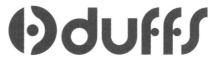

EGO tested several variations of a symbolic mark based on the letter "D" alone and combined with custom typographic treatments appropriate for reproduction in varied media.

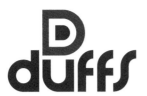

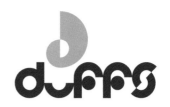

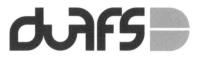

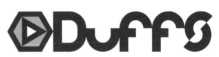

Many of the forms proved to be too static and failed to express forward motion.

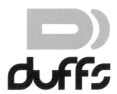
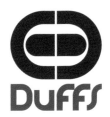

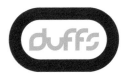
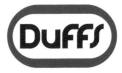

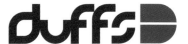

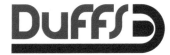
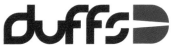

Opening up the forms and spacing out the letters was necessary to prevent the mark from visually imploding when reproduced at small sizes.

DuFFS ▷

Solution: A strong, ownable graphic mark combined with a unique typographic treatment, which can be used together or separately. The sliced "D" shape suggests motion and serves as an arrow pointing forward.

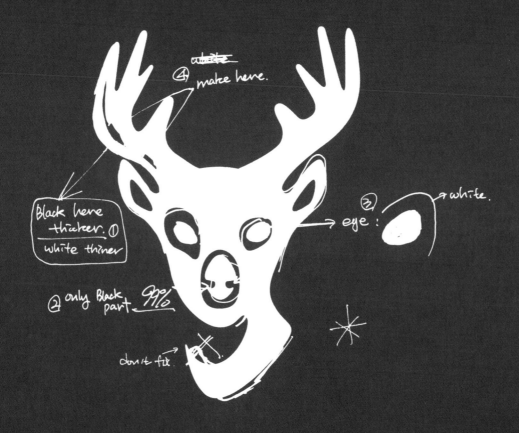

ESPN Outdoors

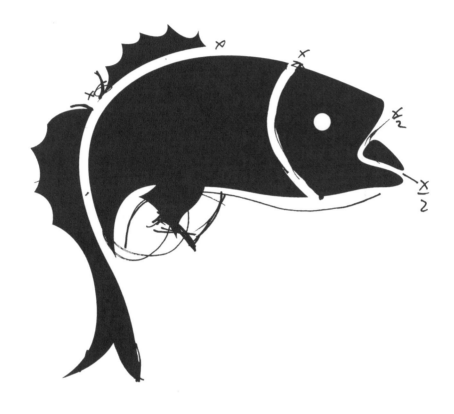

Objective: Develop a set of icons for the new ESPN channel, ESPN Outdoors, to communicate the core of the channel's programming: hunting, camping, and fishing.

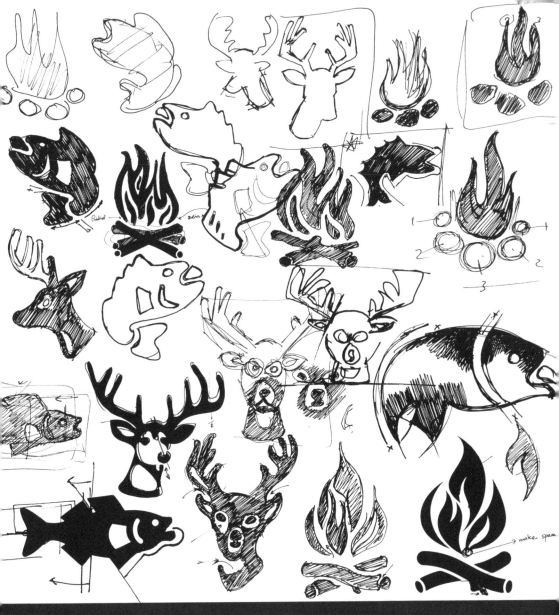

Process: EGO chose to develop symbols for nouns associated with the activities in the channel's planned programming. Icons of a deer, a campfire, and a bass evolved from numerous sketches.

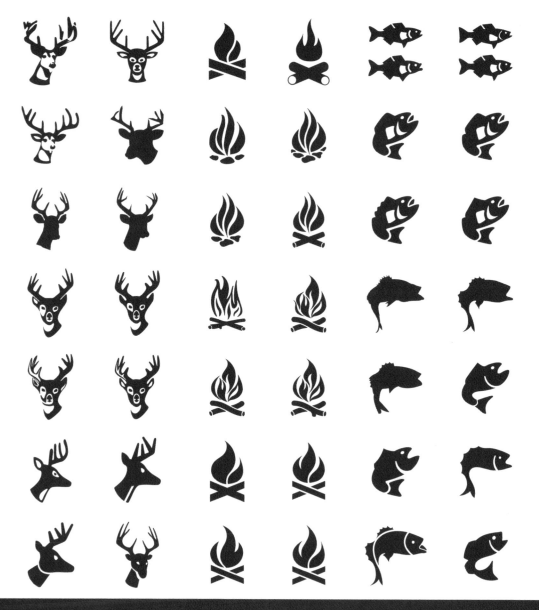

The icons were refined multiple times in an attempt to appeal to knowledgeable outdoor enthusiasts and the general public alike.

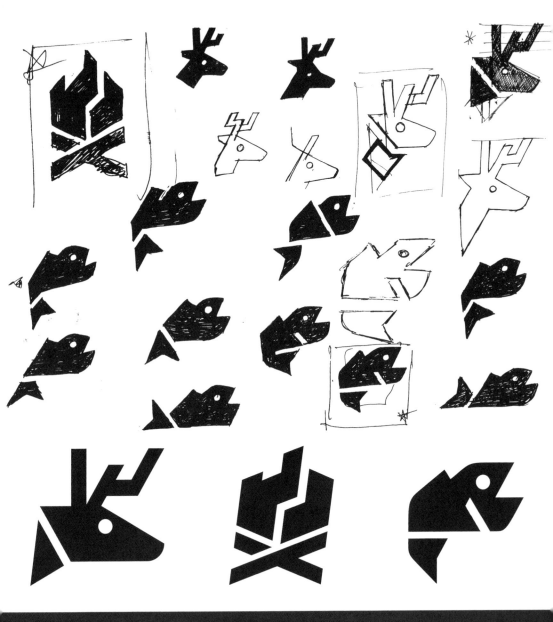

A more geometric approach was also explored to create symbolic representations that would more closely match the modern type treatment of the ESPN logo.

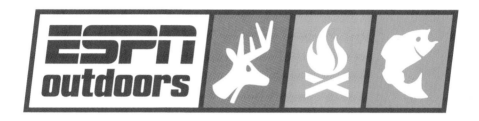

Solution: A set of unique icons that work with the angle of the framing device.

Lee Pipes

Objective: Design a logo for a line of jeans targeted to active pre-teen boys.

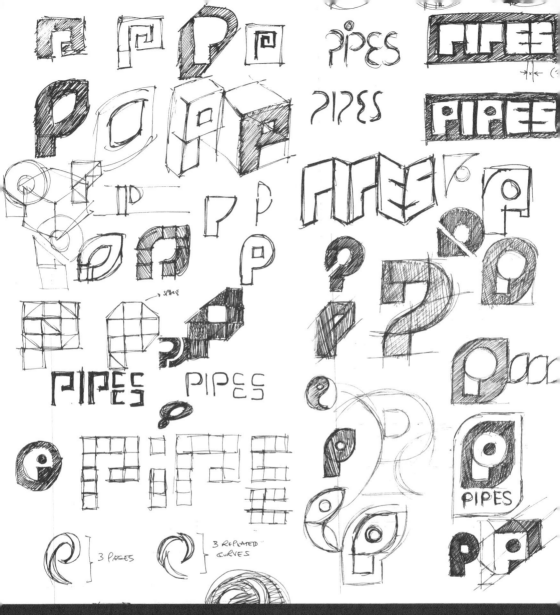

Process: With many other labels under the Lee umbrella, EGO emphasized "Pipes" in order to ensure that the brand stood apart from the other Lee labels.

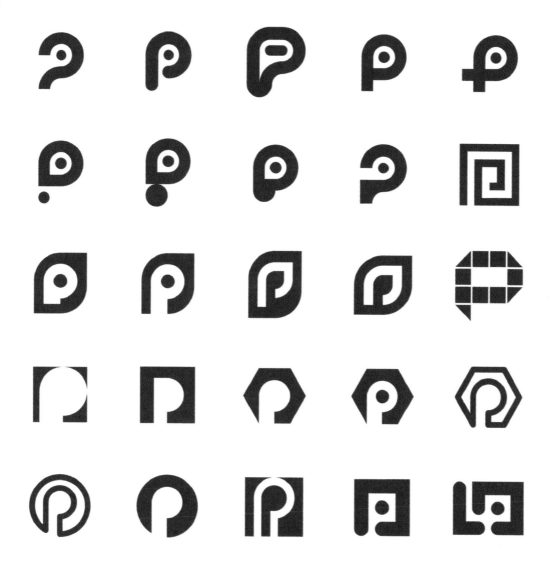

EGO searched for a distinctive mark based on the letter "P" that could easily be applied to a variety of materials, including metal buttons.

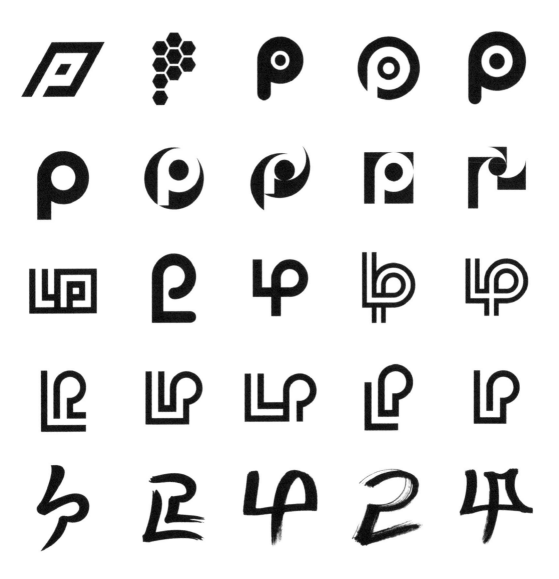

"LP" ligatures were eventually explored in an attempt to bring the "Lee" name back into the logo. Brush stroke ligatures were also designed to evoke a sense of action.

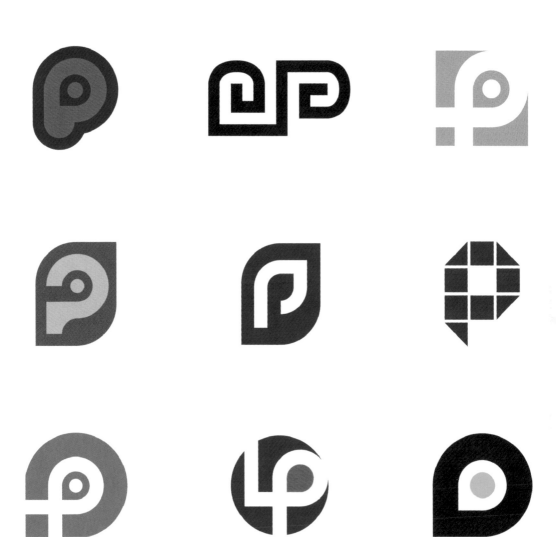

The marks were further abstracted to the point of illegibility. Regardless, their distinctive quality made them attractive options if reinforced with clear type treatments.

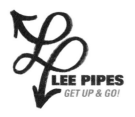 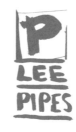 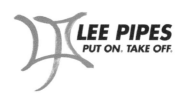

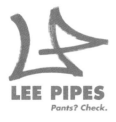 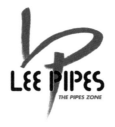 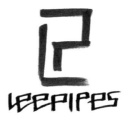

The organic brush stroke ligatures are grounded by the mechanical typesettings. Taglines were integrated to bring a sense of humor which that would be appreciated by the target audience.

PiPES
UNIQUE

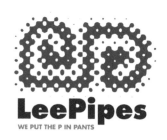

LeePipes
WE PUT THE P IN PANTS

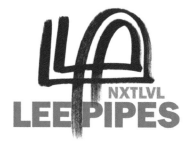

NXTLVL
LEE PIPES

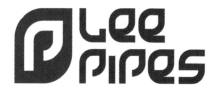

PiPeS
GO FURTHER!

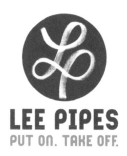

LEE PIPES
PUT ON. TAKE OFF.

Solution: Several final options were provided that spanned an aesthetic range.

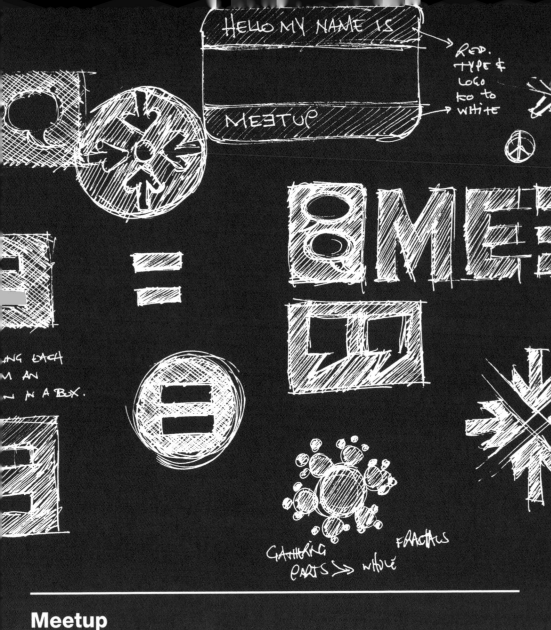

Meetup

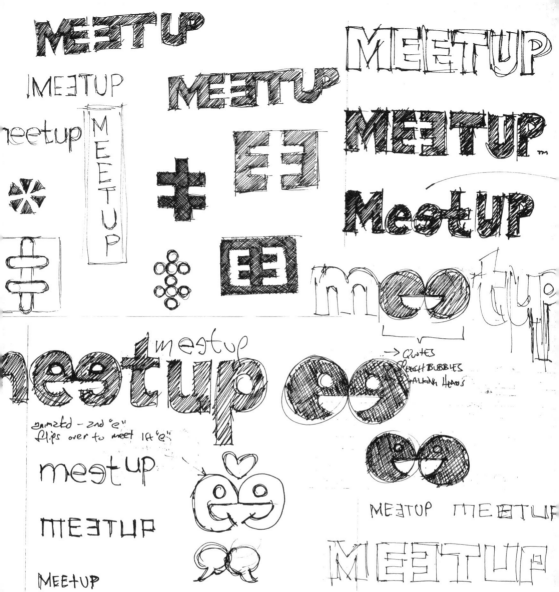

Objective: Design a logo for a company that facilitates the meeting of interest groups through its web site. The logo had to reflect the company's "people-powered" philosophy.

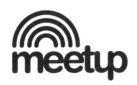 meetup

MEETUP

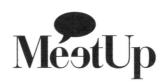 MeetUp

MeetUp

MEETUP

MEETUP

meetup

meetup

$$\boxminus = \ominus$$

MeetUp

MeetUp

MEETUP

MEETUP

MeetUp

Process: Initial investigations took advantage of the double "e" in the company name and used it to symbolize the meeting of two people. This approach was abandoned, as it implied that Meetup was a dating service.

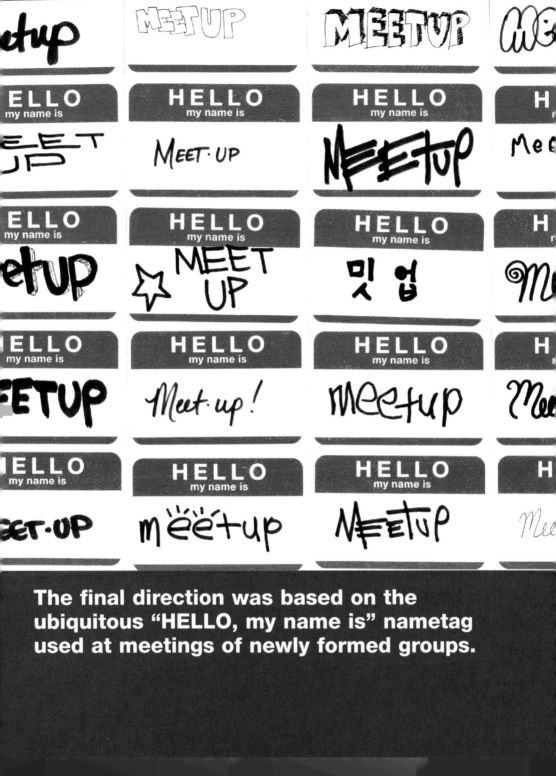

The final direction was based on the ubiquitous "HELLO, my name is" nametag used at meetings of newly formed groups.

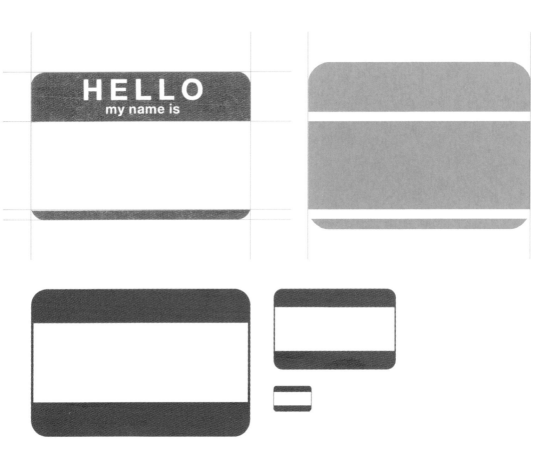

The original nametag shapes were taken apart and reassembled. Side lines were added to define the logo against any background. While equal spacing was at first defined for the top and bottom nametag buns, proportions more akin to the original worked better.

Solution: The final logo is not a set pictorial or typographic mark. It is a dynamic mark wherein the company name is hand-written differently each time inside the standardized nametag frame.

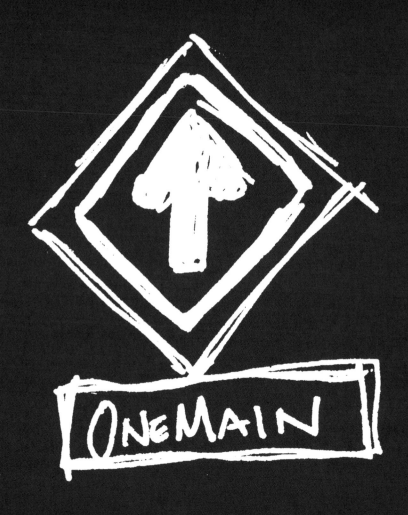

One Main

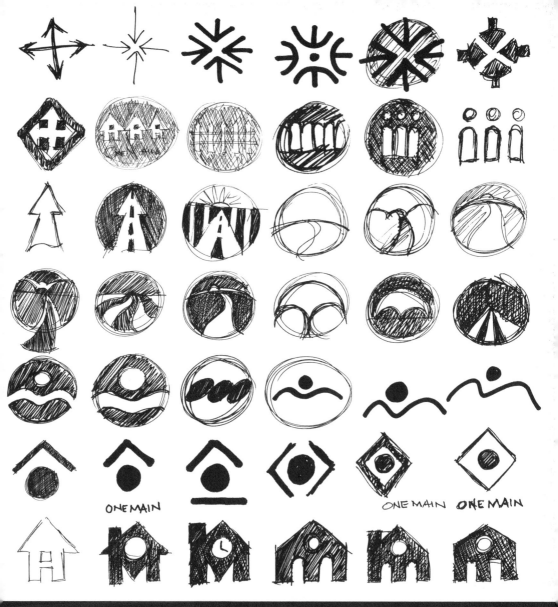

Objective: Design a logo for an internet service provider targeted to first-time users. The mark should reflect the concepts of hometown and community.

ONE MAIN

ONE MAIN ONE MAIN

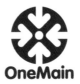

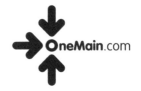

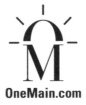

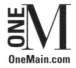

Process: EGO initially explored several different directions expressing community, singularity, growth, vision, and enclosure.

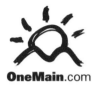 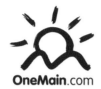 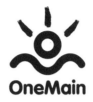 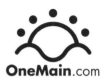

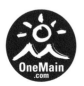 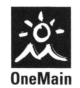

 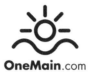 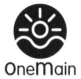

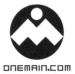 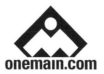 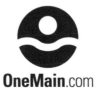 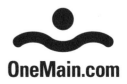

One Main's initials were used as pictorial devices, with the "O" as the shining sun and "M" as landscape (mountains, hills, or rivers).

 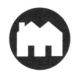

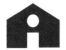 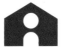 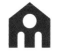

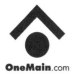

 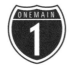

The concept of the street sign was eventually employed to metaphorically bring the information superhighway to a local hometown road.

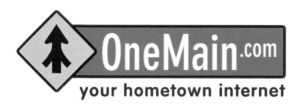

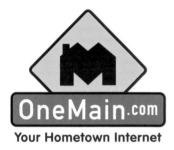

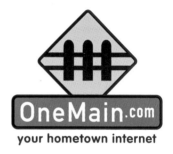

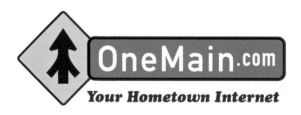

Three pictorial marks (the "M" house, "M" fence, and "3-to-1" arrow) were combined with street signs.

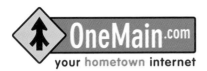

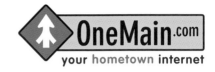

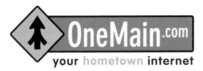

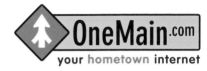

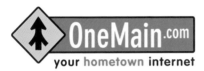

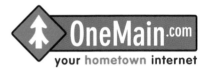

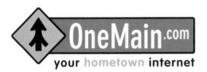

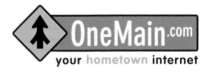

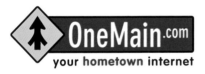

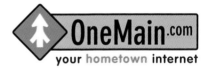

A soft but authoritative color palette that referenced street signage was chosen.

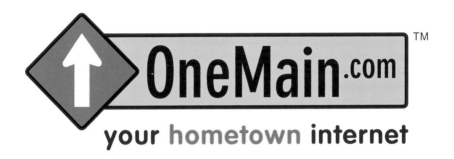

your hometown internet

Solution: A friendly street sign logo that signals the way to an approachable internet.

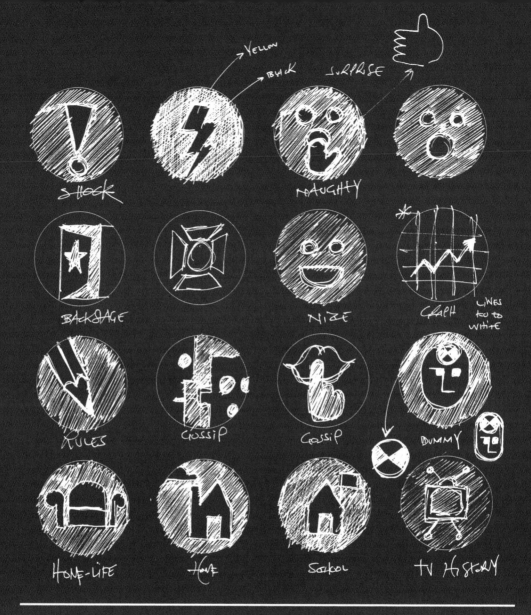

The Truth About

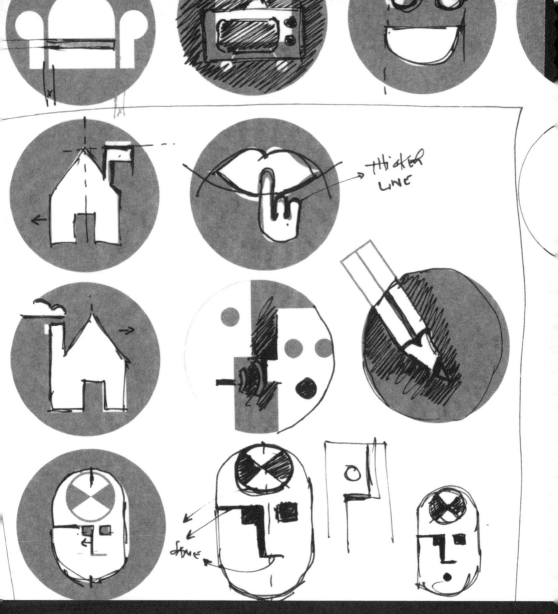

Objective: Create a set of icons communicating simple concepts that work together to be used on a television show.

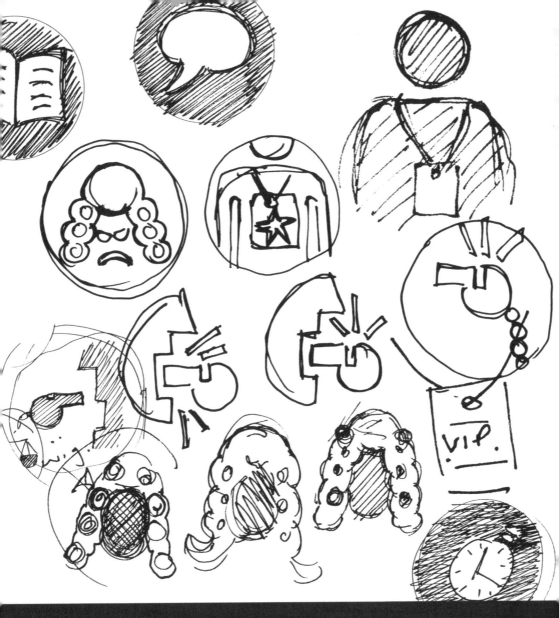

Process: A circle was chosen as a framing device to harmonize the family of icons.

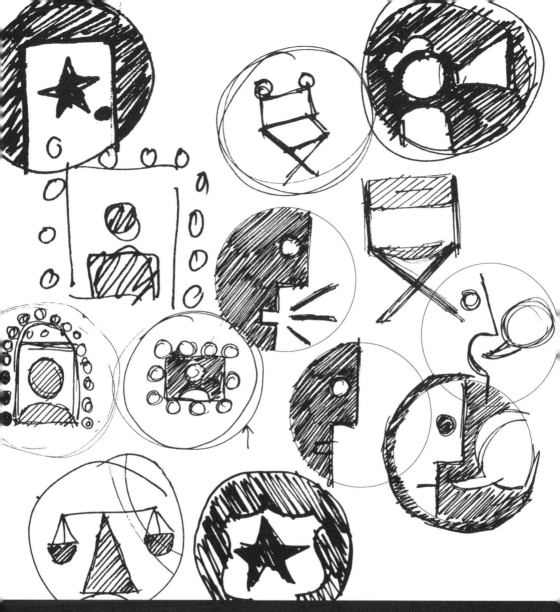

Multiple symbol concepts were explored to represent each word. Casual focus group consensus dictated which directions to develop.

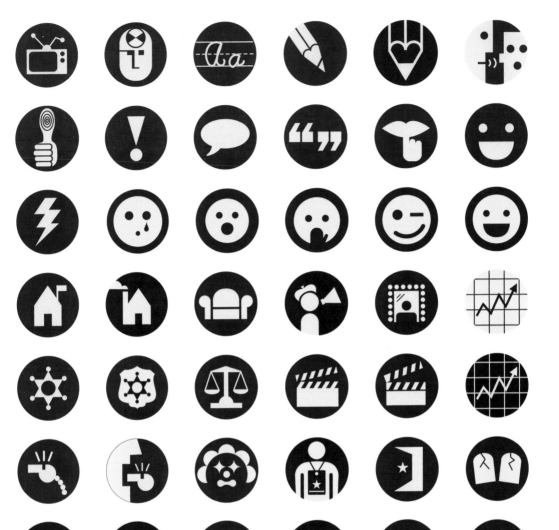

Solution: A system of uniformly designed simple icons in a high-contrast color palette suitable for broadcast.

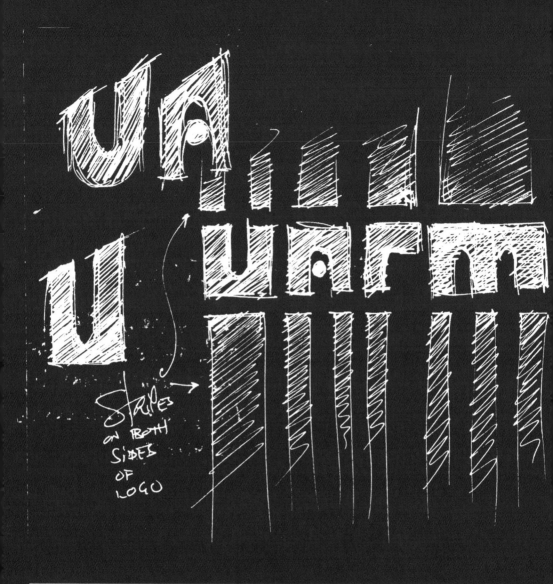

UARM

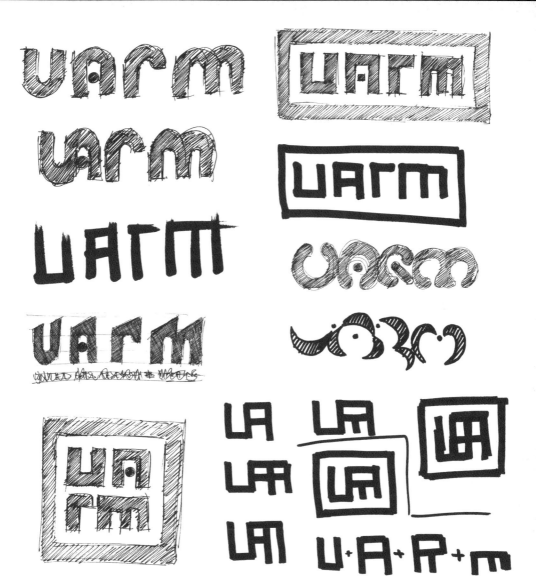

Objective: Design a logo for an art licensing and marketing company.

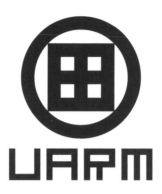

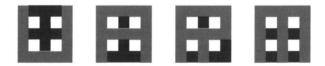

Because UARM works closely with several companies in Japan, one direction referenced the Japanese kanji system of writing.

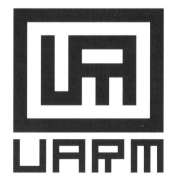

UARM

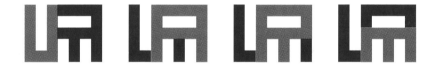

A rectilinear composite of all the letters in the company name creates a bold singular mark.

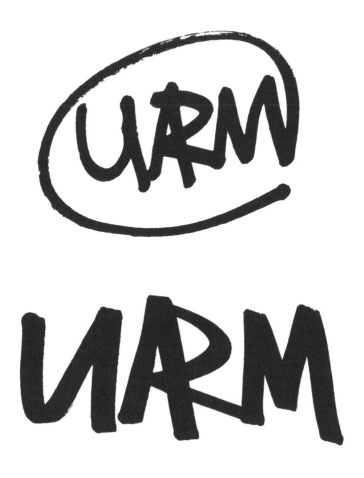

UARM stands for Urban Arts Research and Marketing. Using the forms of graffiti tags as the basis for the UARM logo reinforces the "Urban Arts" part of the company name.

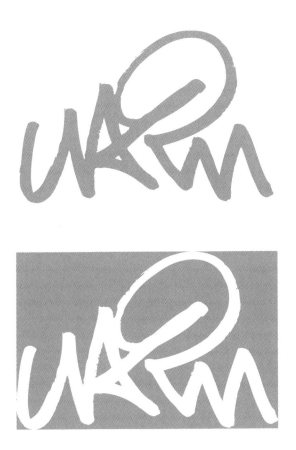

Solution: The final mark is an energetic marker tag that can stand alone or be caged in its geometric environment.

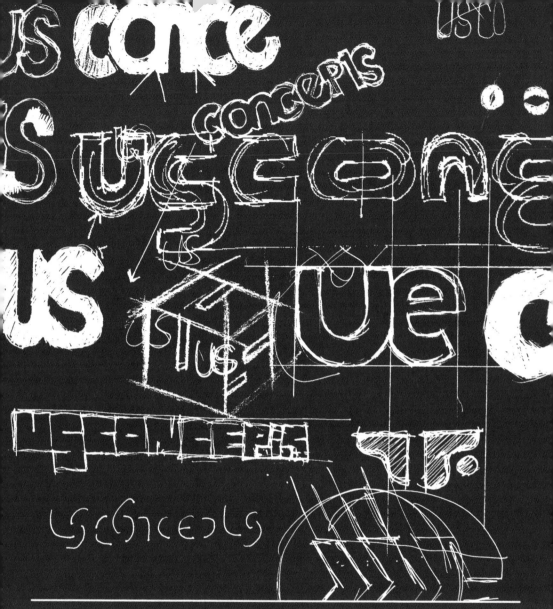

U.S. Concepts

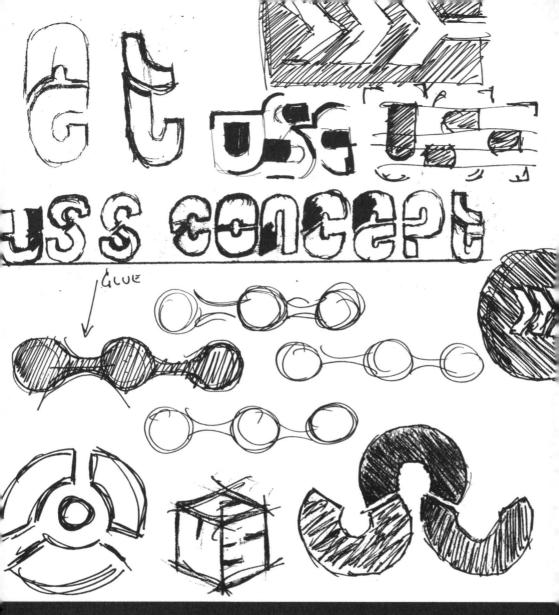

Objective: Re-brand one of the nation's leading event and entertainment marketing firms to reflect the company's three tenets: passion, execution, and results.

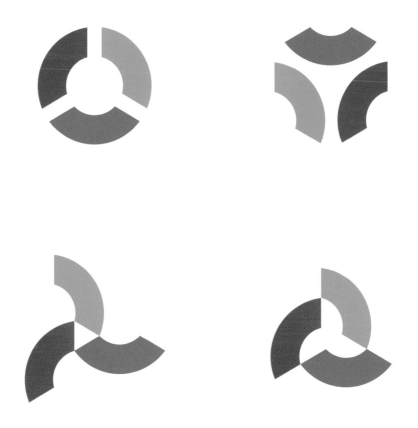

Process: EGO created abstract marks composed of a single form repeated three times.

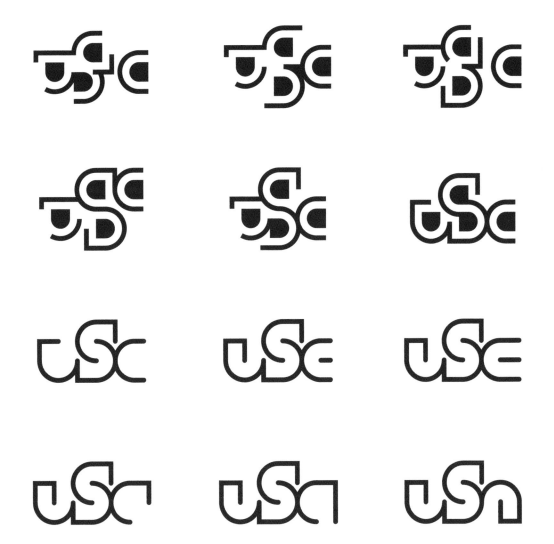

Ligatures for USC were also explored but later dropped in favor of developing an abstract mark that would better reflect the company's principles.

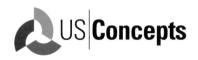

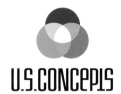

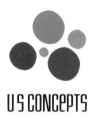

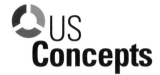

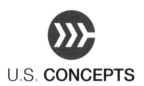

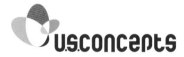

Highly stylized forms evolved from initial brainstorms, which produced such diverse concepts as puzzle pieces, light, the Simon Says electronic game, Rubik's Cube, the military, chain links, droplets, and the cosmos.

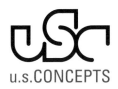

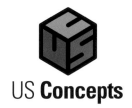

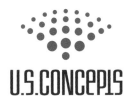

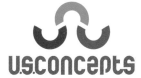

Numerous final logos were presented.

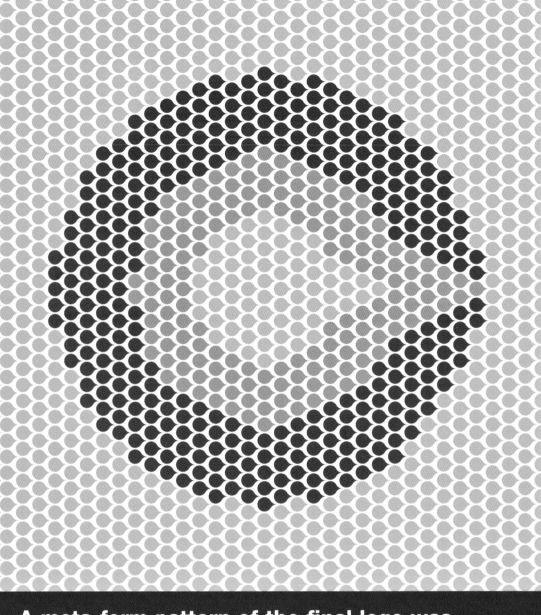

A meta-form pattern of the final logo was designed and used for animations.

U.S.concepts

Solution: A mark consisting of a passionate color palette, exacting execution points that serve as arrows to the company name, and a target symbolizing results. An ownable bold type treatment of custom forms creates a stable, uniform horizontal stripe.

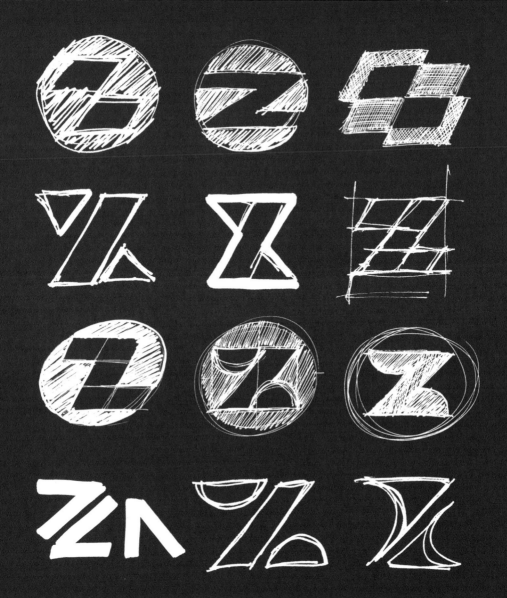

Zakka

Objective: Design a logo for a New York–based bookstore specializing in importing cutting-edge art and design books from Japan.

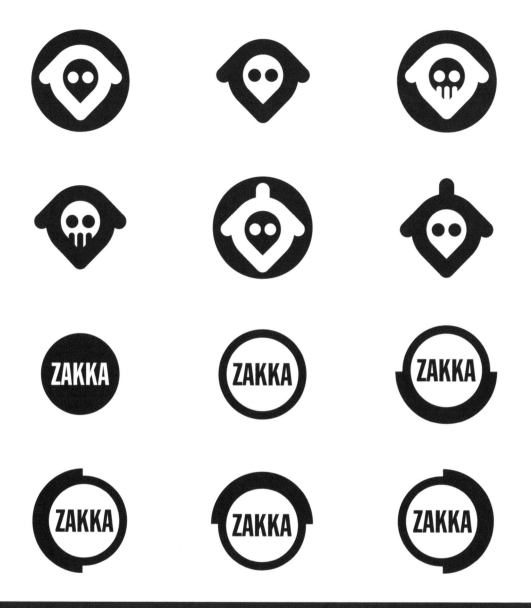

Process: Initially, an animal-like mascot and a circle representing the global path traveled by Zakka's products were explored. These directions were dropped in favor of exploiting the possibilities of abstracting the "Z".

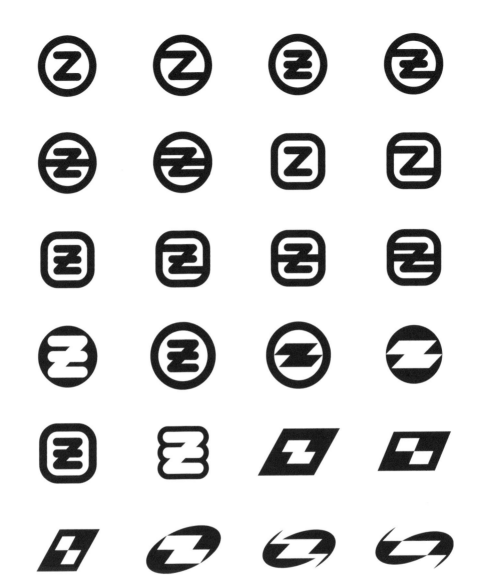

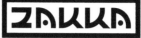

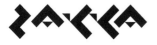

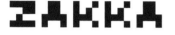

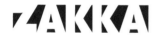

Playing off the many angles in the capital letters of the company name, custom letterforms were designed to create a purely typographic mark.

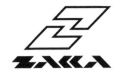

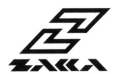

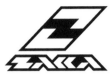

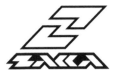

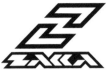

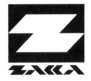

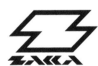

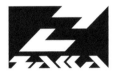

The final typographic treatment of the word "Zakka" uses only the angled legs of a "K" to represent that letter. Although the repeated shape also looks like two "C"s, both readings produce the sound needed to pronounce "Zakka."

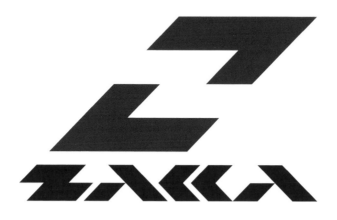

Solution: A visually sharp mark that matches the crisp, phonetic sound of the company name. The use of color hints at the store's Japanese book selection, while the mark moves both east and west.

Icons & Logos

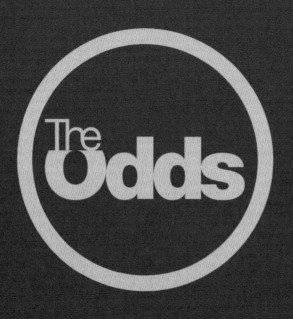

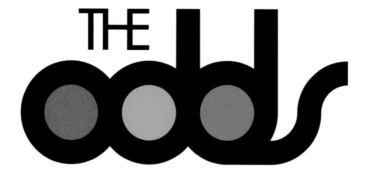

THE PICTURE FACTORY INC

SPIKEgallery

spike

A D E R O

A D E R O

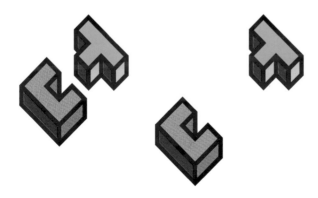

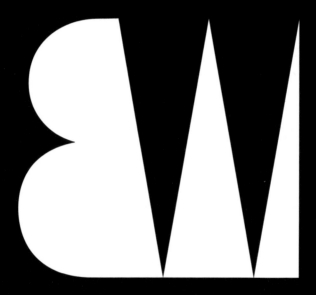

plexifilm

VANIMAL ZOO

Saturnine

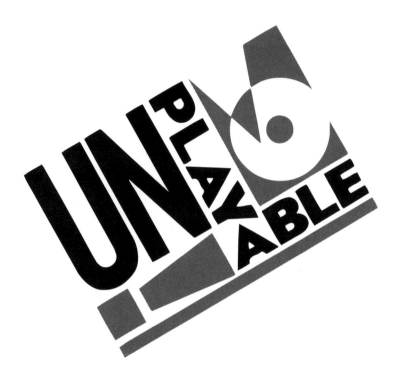

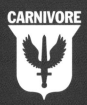

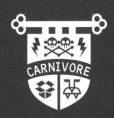

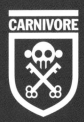

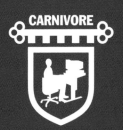

ungaro
FEVER

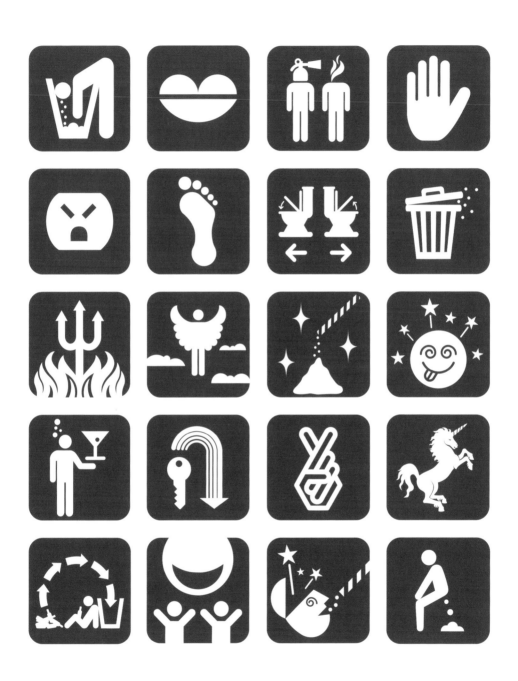

NEVER

IAMTRYINGTO
BREAKYOURHEART
A FILM ABOUT WILCO BY SAM JONES

Bookshop / **Librairie**
Fashion / **Mode**
Gallery / **Galerie**

NEW **YO**RK

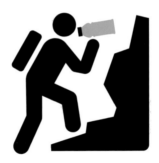

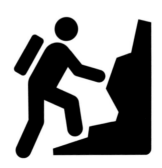

URBANOASIS

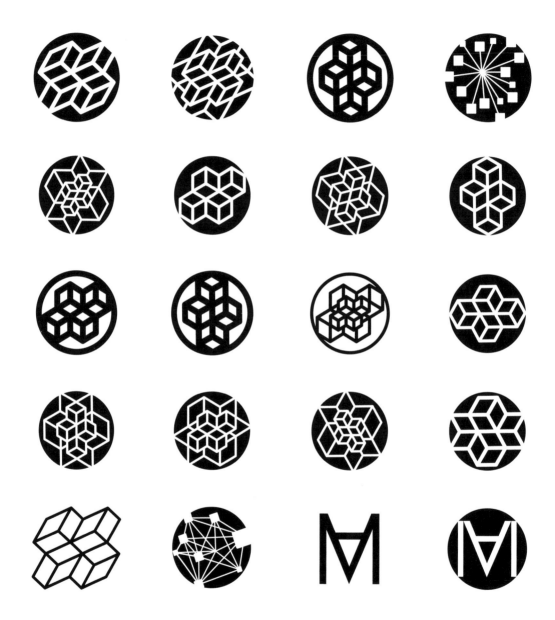

RSUB

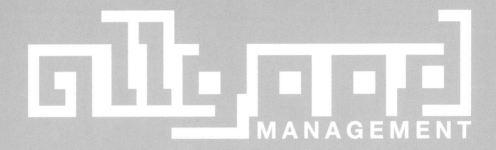

GENERIC COSTUME

KYOTO

Twin

TRAINING CAMP

eCOVERAGE

THEPHOIDS

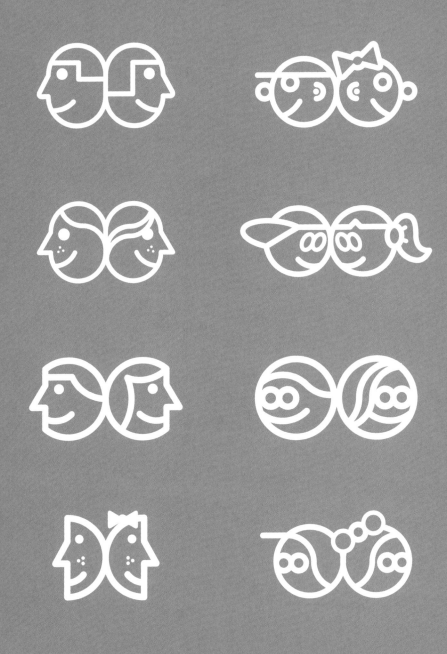

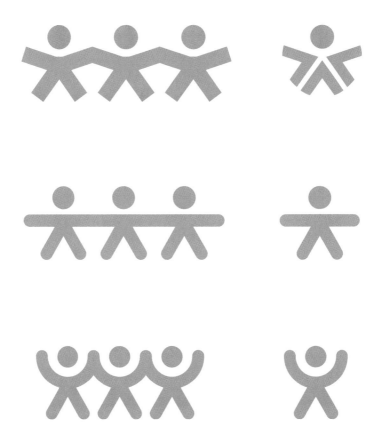

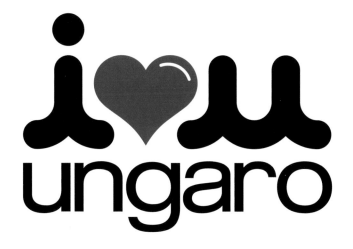

PopSmear
*Post**Cards***

GOOD TEDDY BEARS

CNS

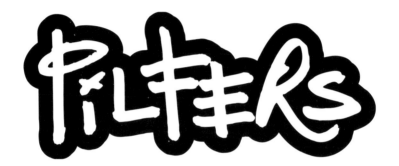

öönä

bloodhoundgang

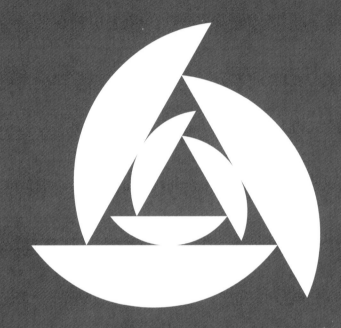

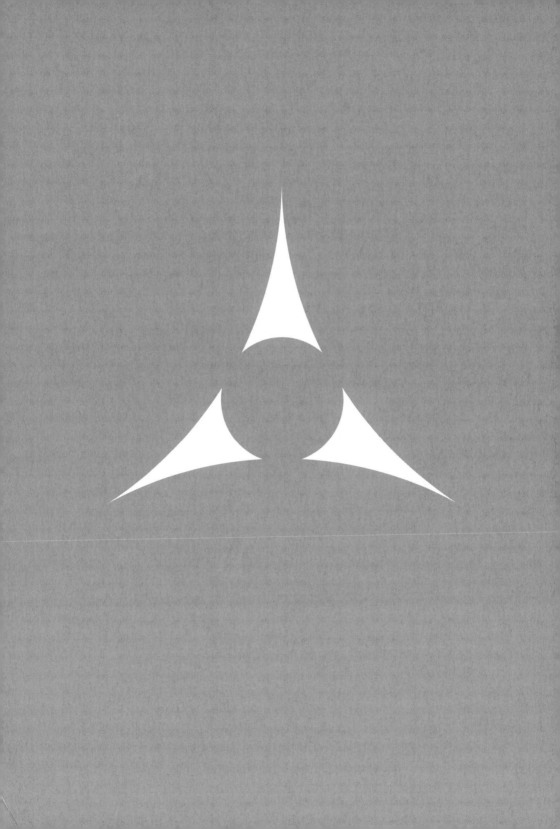

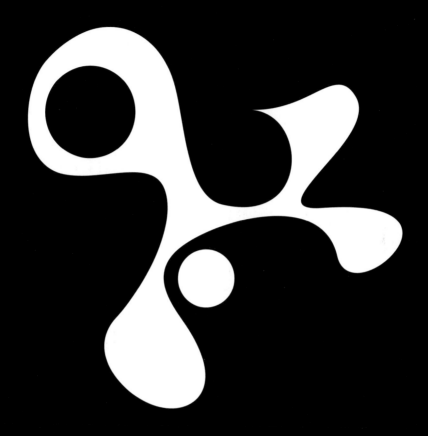

buSt

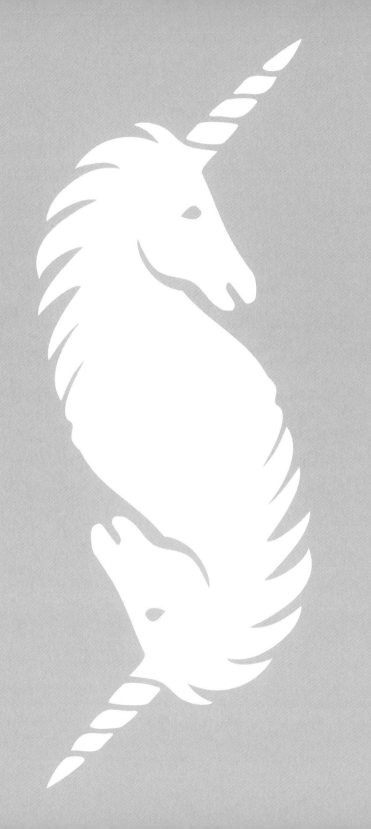

kllyrdls

fotolog

BE INDIVISIBLE

End